This book belongs to:

- -

TRACING PRACTICE
VOL. 2

CURSIVE WRITING PRACTICE BOOK & COLORING BOOK

Animal coloring books for toddlers

BY THE ACTIVITY BOOKS STUDIO

TRACING PRACTICE

Animal coloring books for toddlers

Copyright © 2018 The Activity Books Studio

All rights reserved. No part of this publication may be reproduced, distributed, or transmitted in any form or by any means, including photocopying, recording, or other electronic or mechanical methods, without the prior written permission of the publisher, except in the case of brief quotations embodied in critical reviews and certain other noncommercial uses permitted by copyright law.

Alphabet Chart

Aa Bb Cc Dd Ee

Ff Gg Hh Ii Jj

Kk Ll Mm Nn Oo

Pp Qq Rr Ss Tt

Uu Vv Ww Xx Yy

Zz

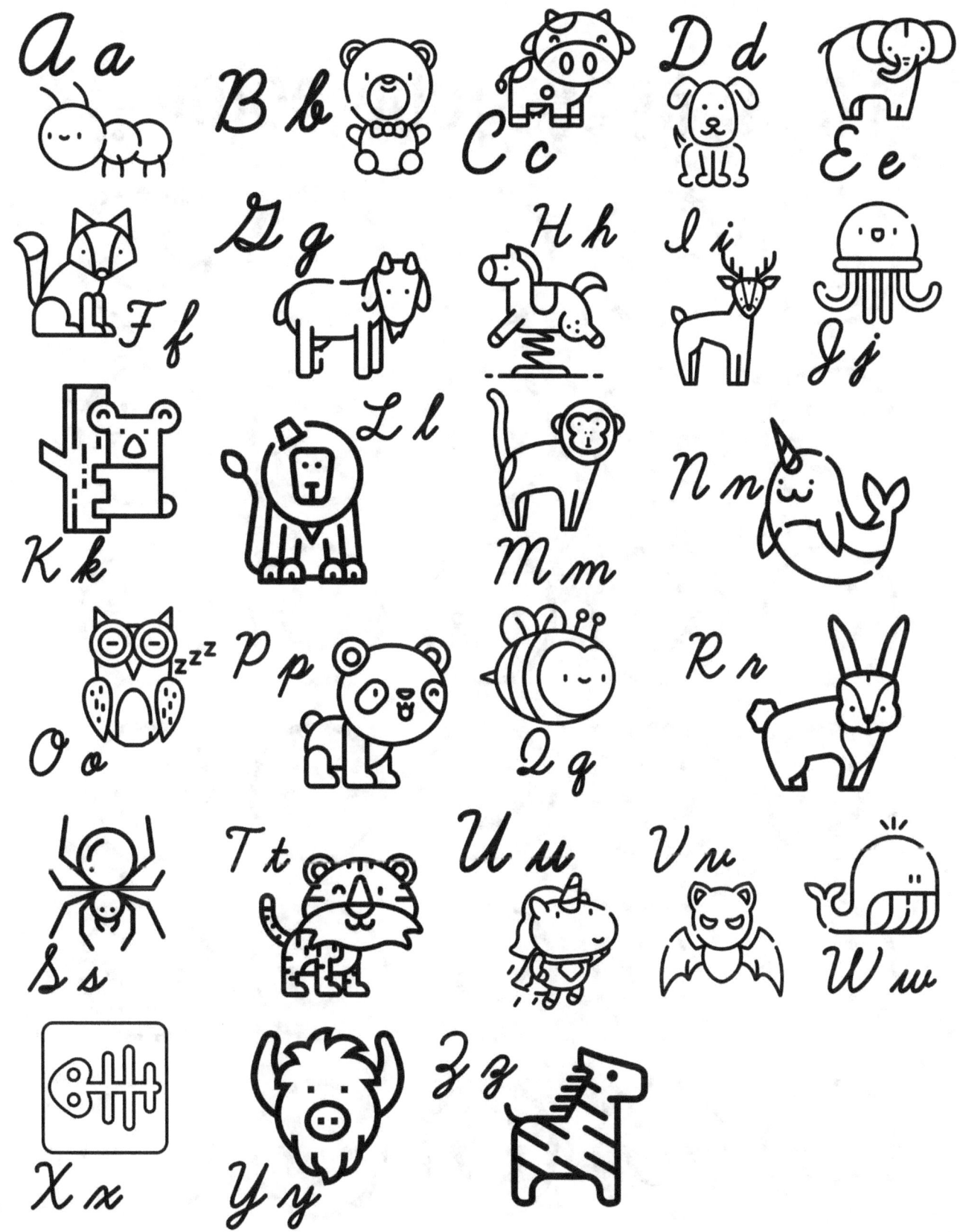

Alphabet letter Worksheets

A a

A is for ant.

B b

B is for bear.

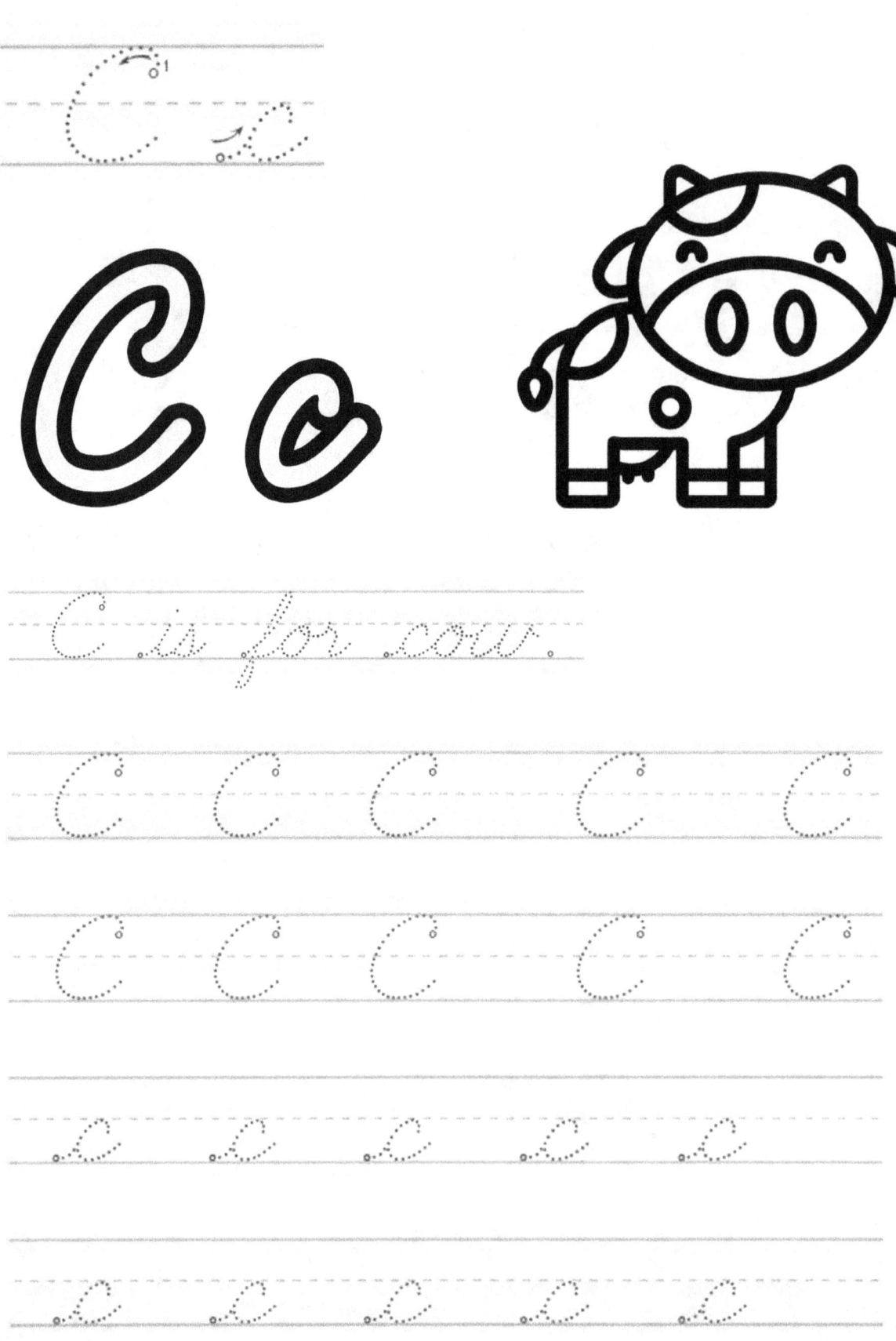

D d

D is for dog.

 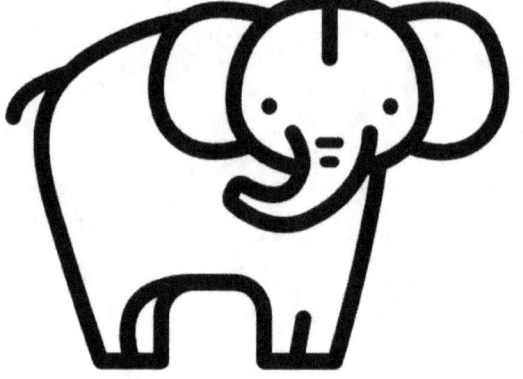

E is for elephant.

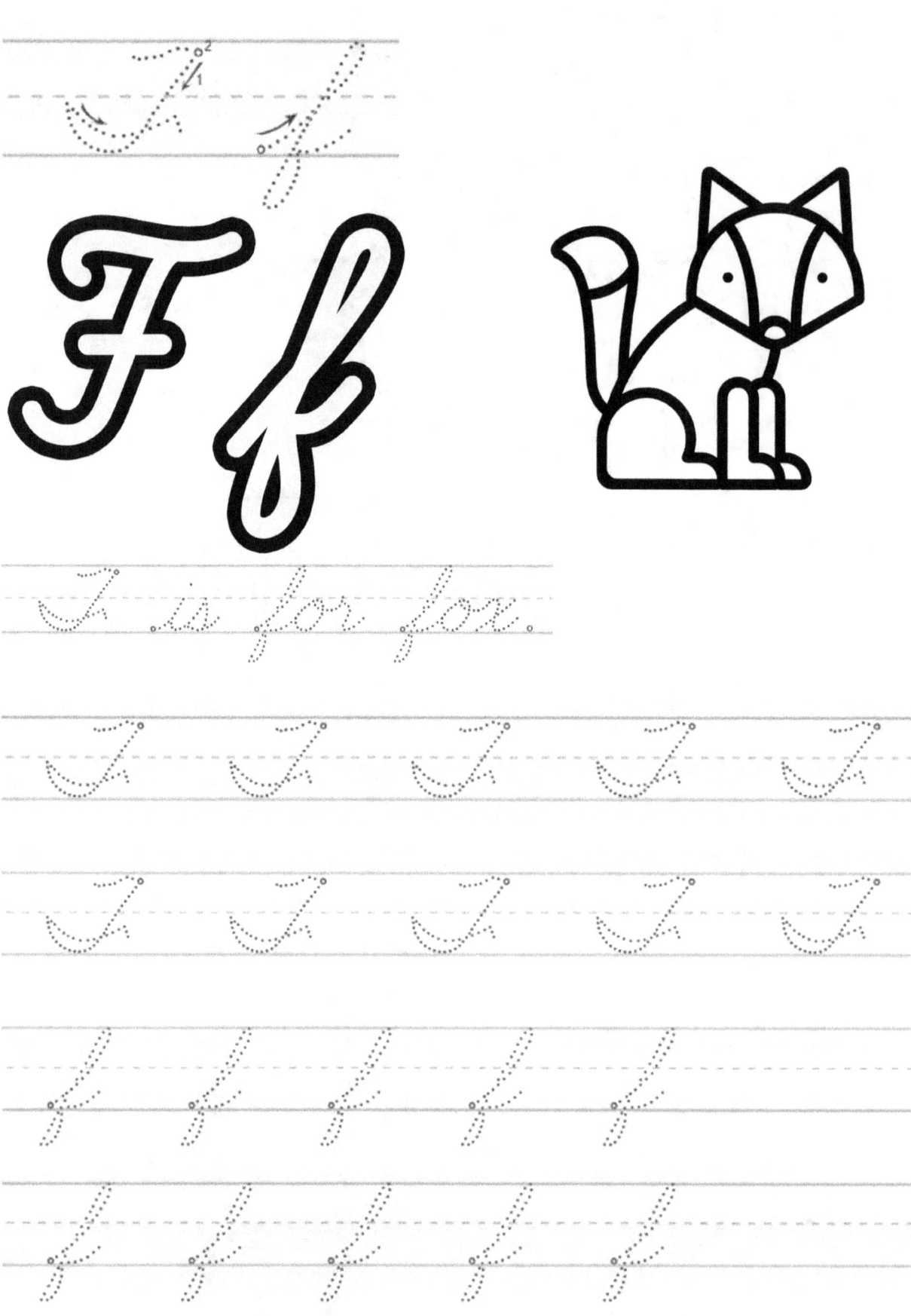

G g is for goat.

H h

H is for horse.

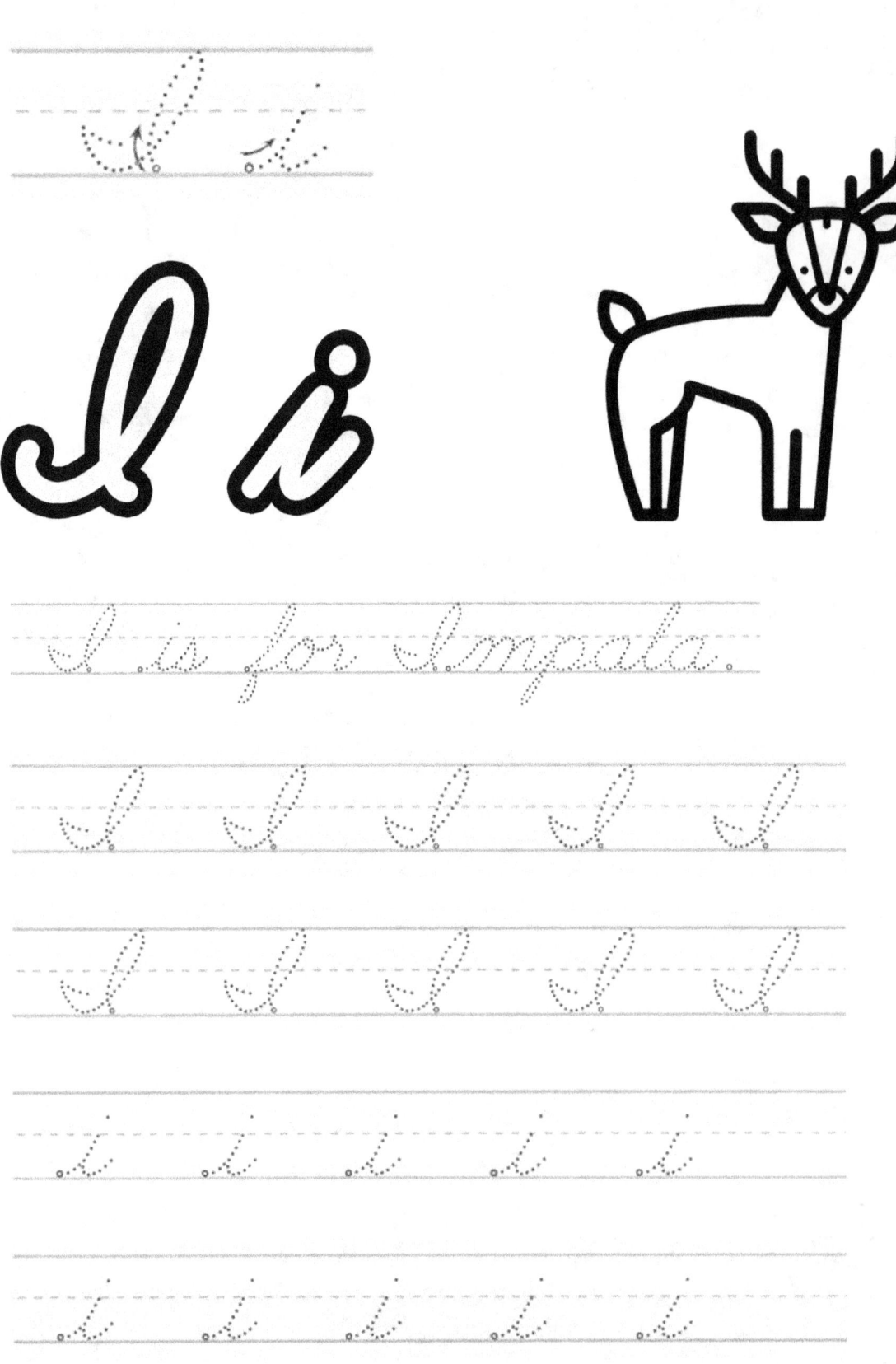

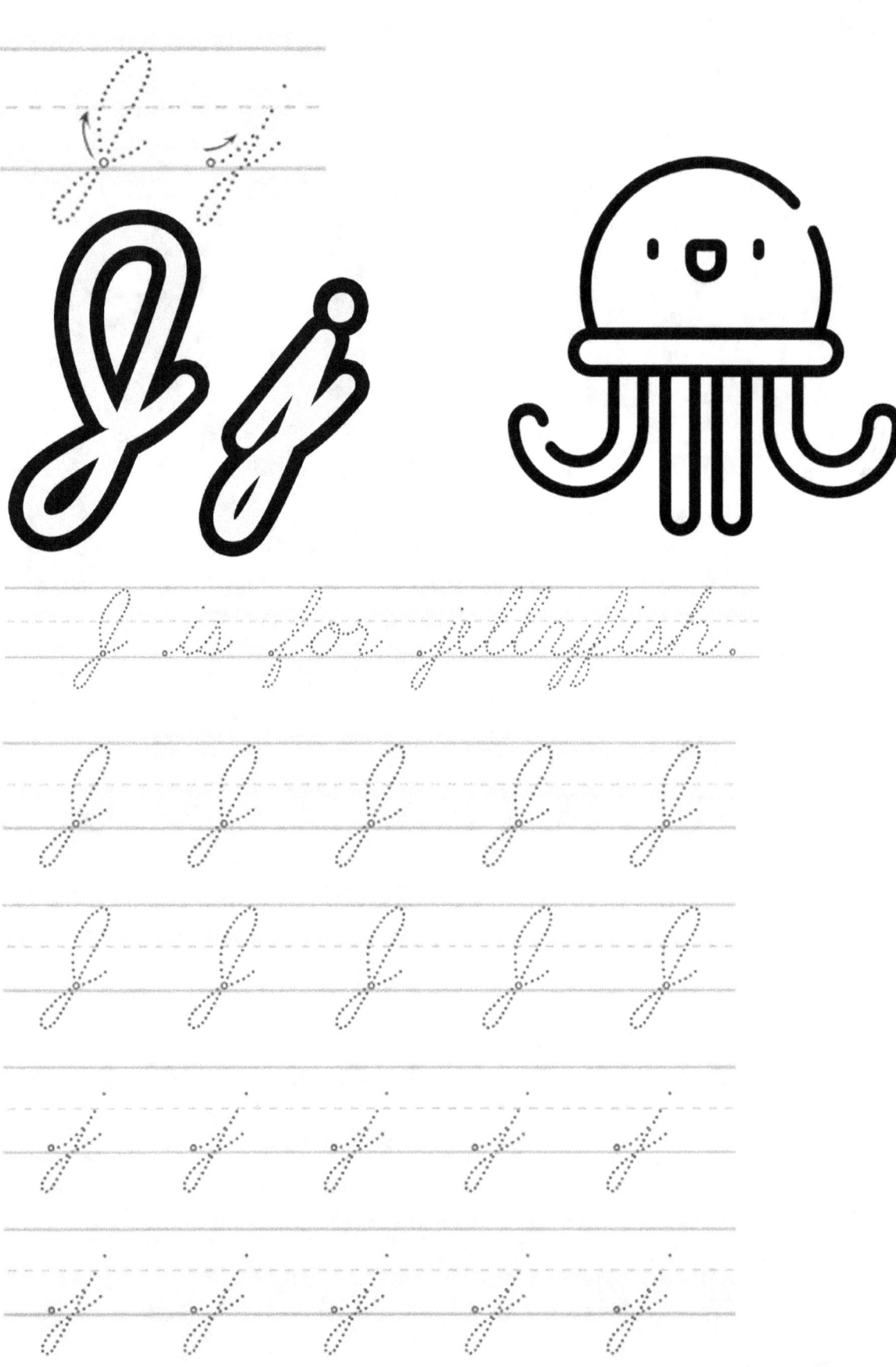

K k

K is for koala.

L l

L is for lion.

M m

M is for monkey.

N n

N is for narwhal.

n n n n n

n n n n n

m m m m m

m m m m m

n n n n n

n n n n n

m m m m m

m m m m m

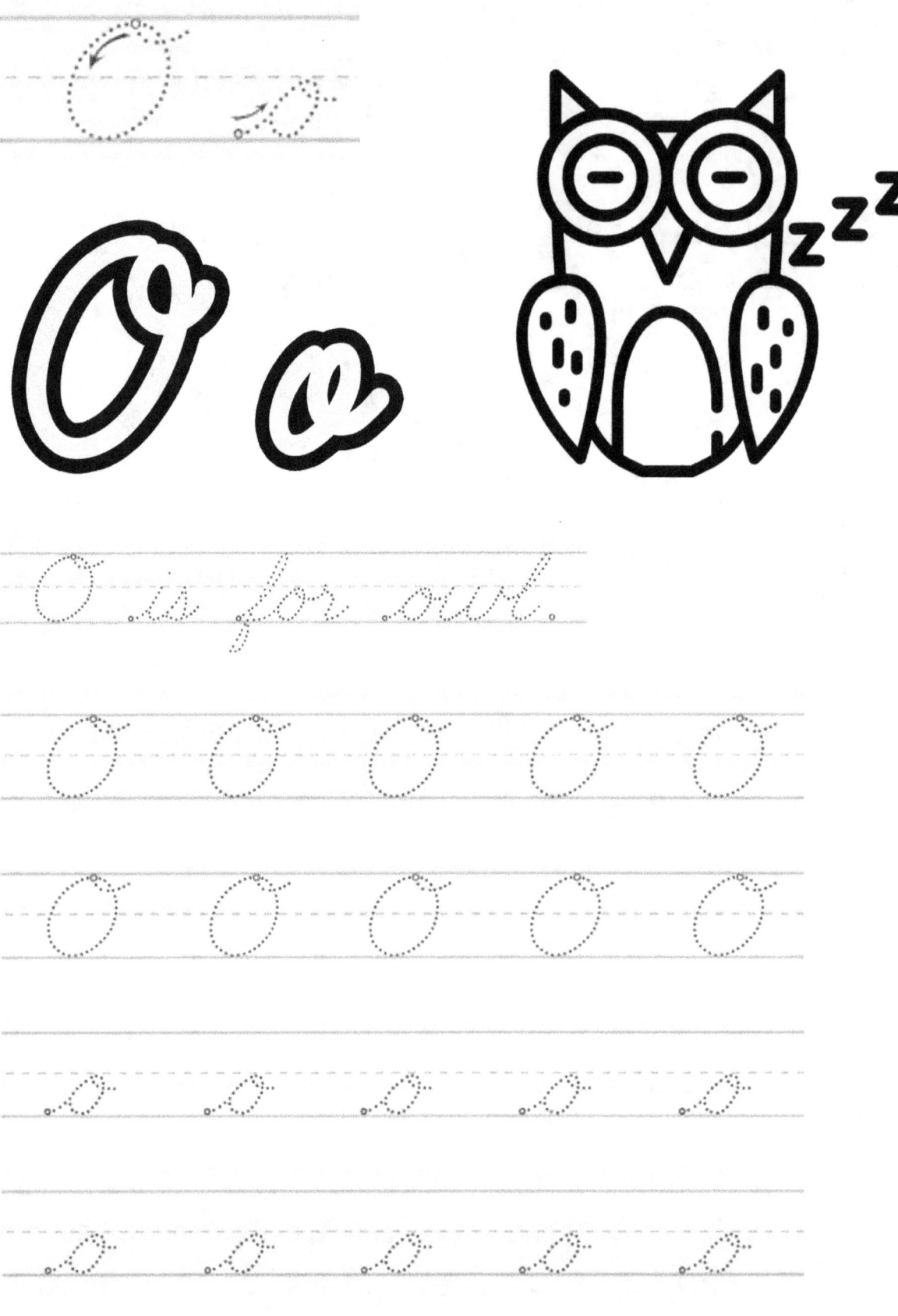

P p

P is for panda.

Q is for queen bee.

R r

R is for rabbit.

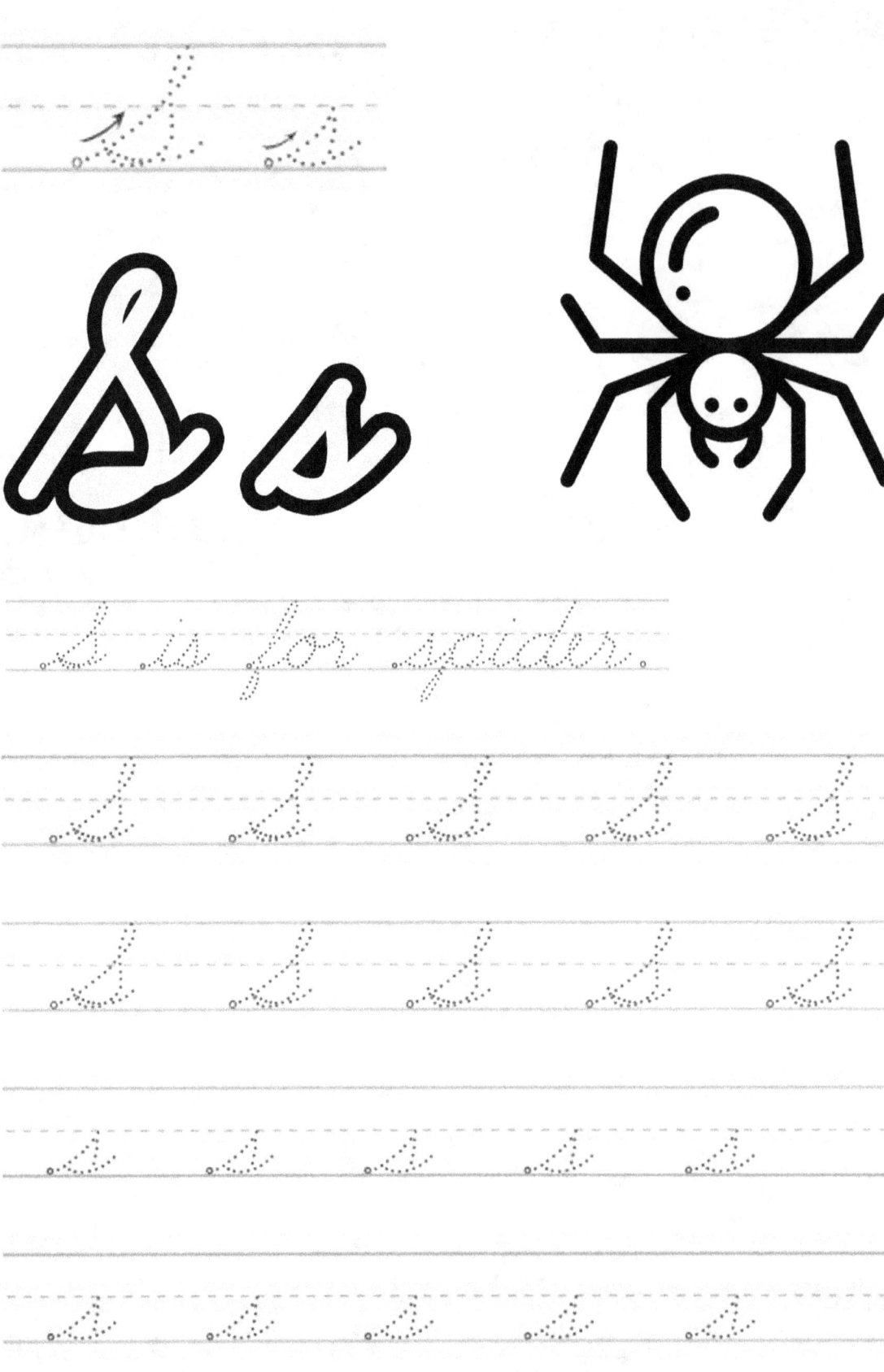

T t

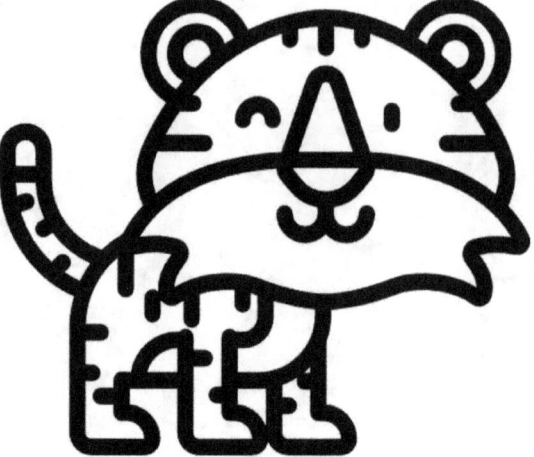

T is for tiger.

U u

U is for unicorn.

Vv

V is for vampire bat.

W w

W is for whale.

Yy

Y is for yak.

Z is for zebra.

THIS AWARD IS PRESENTRD TO

★ Trying hard

★ happy learning

★ never give up

www.ingramcontent.com/pod-product-compliance
Lightning Source LLC
Chambersburg PA
CBHW081630220526
45468CB00009B/2379